Ninja Dual Zone Air Fryer Cookbook UK 2023

1000 Days Quick-To-Make, Delicious and Crispy Homemade Recipes for Your Ninja Dual Air Fryer.

By Corinne Laborde

CONTENTS

INTRODUCTION

Ninja Dual Zone Air Fryer Is the Best Kitchen Appliance You Should Have Right Now!

This appliance has a striking design with two roomy drawers, removable non-stick crisper plates, and a matte black exterior accentuated with superior shiny stainless steel. You will undoubtedly be impressed by the construction and adaptability of the Ninja Dual air fryer.

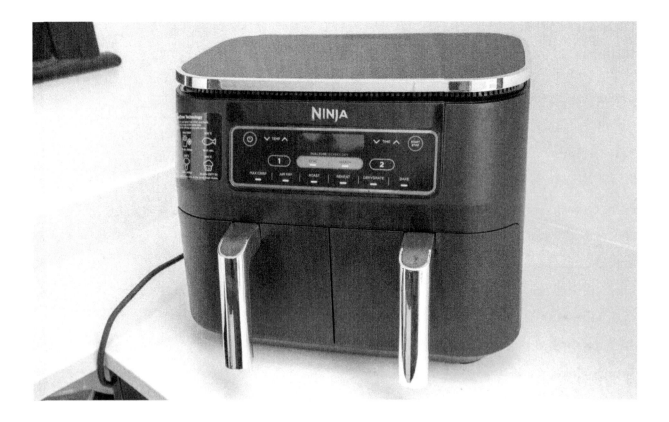

It can roast, bake, reheat, and cook food from frozen to crispy in a matter of minutes in addition to dehydrating fruits and vegetables. As an air fryer, it is easy to use. Additionally, Ninja claims that it consumes 75% less energy than a typical oven.

When it comes to cooking, timing is essential. The Ninja Food Dual Zone Air Fryer makes the timing and duration decisions. You can change the temperatures, timings, and cooking programs for both drawers by using different cooking zones.

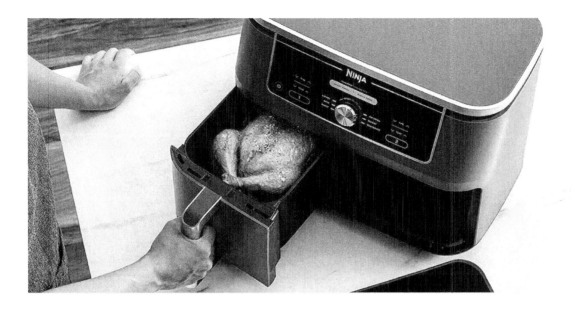

- **TWO INDEPENDENT BASKETS:** The original air fryer, the XL air fryer eliminates back-to-back cooking like a traditional single-basket air fryer by enabling you to prepare two different meals at once.

- **SMART FINISH & MATCH COOK:** DualZone Technology offers you the choice of the Smart Finish function, which allows you to cook two items in two different ways that finish at the same time, or the Match Cook button, which makes it simple to replicate settings between zones to use the entire 8-qt capacity.

- **6-IN-1 FUNCTIONALITY:** Includes six flexible cooking modes, including air fry, air broil, roast, bake, reheat, and dehydrate.

- **XL CAPACITY:** The 8-quart air fryer's capacity can accommodate up to 2 kilograms of chicken wings or French fries for convenient family meals.

- **DIFFERENT HEATING ZONES:** Each of the two distinct, 4-quart zones has a rapid heater, cyclonic fan, and cooking basket.

- **EASY CLEANING:** Crisper plates that can go in the dishwasher and easily sanitized baskets.

- **LESS FAT:** Using conventional air frying methods may result in up to 75% more fat. Deep-fried, hand-cut French fries were put to the test.

- **WIDE TEMPERATURE RANGE:** 40°C to 230°F enables you to gently remove moisture from food while gently cooking and crisping food with convection heat.

7 Fantastic Reasons To Buy Ninja Dual Zone Air Fryer

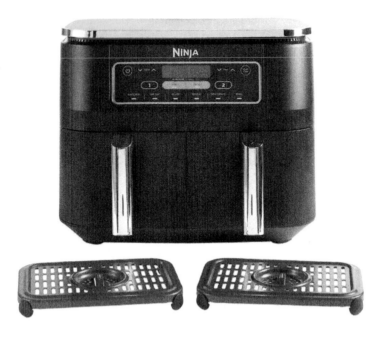

1. Highly convenient

2. Slim design and overall sleek look and feel

3. Cooks food fast

4. Amazing air-fried results

5. Great for cutting down on fried foods

6. You can Sync and Match drawers

7. Very safe to use

BREAKFAST RECIPES

Eggs and Tomatoes

Prep Time: 5 Min | Cook Time: 10 Min | Serves: 4

Calories: 200.5 | Fat: 4.1g | Carbs: 12.7g | Protein: 3.2g

INGREDIENTS

- 4 eggs
- 60ml milk
- 2 tbsp parmesan, grated
- Salt and black pepper to the taste
- 8 cherry tomatoes, halved
- Cooking spray

DIRECTIONS

1. Apply frying spray to your air fryer and turn the temperature up to 95°C.
2. Whisk eggs, cheese, milk, salt, and pepper together in a bowl.
3. Put this mixture in your air fryer, and cook it there for 6 minutes.
4. After 3 minutes, add tomatoes, divide the scrambled eggs among dishes, and then serve.

Mushroom Quiche

Prep Time: 10 Min | Cook Time: 10 Min | Serves: 4

Calories: 211.5 | Fat: 4.1g | Carbs: 6.7g | Protein: 7.2g

INGREDIENTS

- 1 tbsp flour
- 1 tbsp butter, soft
- 9 inch pie dough
- 2 button mushrooms, chopped
- 2 tbsp ham, chopped
- 3 eggs
- 1 small yellow onion, chopped
- 150ml heavy cream
- A pinch of nutmeg, ground
- Salt and black pepper to the taste
- ½ tsp thyme, dried
- 60g Swiss cheese, grated

DIRECTIONS

1. Roll the pie crust out on a flour-dusted surface.
2. Firmly press down on the pie plate that comes with your air fryer.
3. Combine the butter, heavy cream, salt, pepper, thyme, and nutmeg in a bowl with the mushrooms, ham, onion, and eggs.
4. Spread this over the pie shell, top with Swiss cheese, and put the pie pan in the air fryer.
5. Bake your quiche for 10 minutes at 200°C.
6. Cut into slices and serve as breakfast.

Smoked Tofu Breakfast

Prep Time: 10 Min | Cook Time: 12 Min | Serves: 2

Calories: 171.5 | Fat: 4.1g | Carbs: 11.7g | Protein: 4.2g

INGREDIENTS

- 1 tofu block, pressed and cubed
- Salt and black pepper to the taste
- 1 tbsp smoked paprika
- 60g cornstarch
- Cooking spray

DIRECTIONS

1. Spray cooking spray on the basket of your air fryer and set the temperature to 185°C
2. Combine the tofu with the smoked paprika, cornstarch, salt, and pepper in a bowl.
3. Place the tofu in the basket of your air fryer and cook for 12 minutes, shaking the fryer every four minutes.
4. Divide into bowls and serve for breakfast.

Tomato Breakfast Quiche

Prep Time: 10 Min | Cook Time: 30 Min | Serves: 1

Calories: 240.1 | Fat: 6.1g | Carbs: 14.2g | Protein: 6.2g

INGREDIENTS

- 2 tbsp yellow onion, chopped
- 2 eggs
- 60ml milk
- 125g gouda cheese, shredded
- 60g tomatoes, chopped
- Salt and black pepper to the taste
- Cooking spray

DIRECTIONS

1. Spray some cooking spray inside a ramekin.
2. Crack the eggs, then whisk in the onion, milk, cheese, tomatoes, salt, and pepper.
3. Place this in the pan of your air fryer, and cook for 30 minutes at 170°C.
4. Serve warm and enjoy!

Tofu and Mushrooms

Prep Time: 10 Min | Cook Time: 10 Min | Serves: 2

Calories: 141.1 | Fat: 4.1g | Carbs: 8.2g | Protein: 3.1g

INGREDIENTS

- 1 tofu block, pressed and cut into medium pieces
- 250g panko bread crumbs
- Salt and black pepper to the taste
- ½ tbsp flour
- 1 egg
- 1 tbsp mushrooms, minced

DIRECTIONS

1. Egg, mushrooms, flour, salt, and pepper should all be thoroughly combined in a bowl.
2. Place the tofu pieces in your air fryer and cook for 10 minutes at 175°C after dipping them in the egg mixture and panko bread crumbs.
3. Serve and enjoy!

Broccoli Quiche

Prep Time: 10 Min | Cook Time: 20 Min | Serves: 2

Calories: 213.1 | Fat: 4.1g | Carbs: 12.2g | Protein: 3.1g

INGREDIENTS

- 1 broccoli head, florets separated and steamed
- 1 tomato, chopped
- 3 carrots, chopped and steamed
- 50g cheddar cheese, grated
- 2 eggs
- 60ml milk
- 1 tsp parsley, chopped
- 1 tsp thyme, chopped
- Salt and black pepper to the taste

DIRECTIONS

1. Whisk eggs, milk, parsley, thyme, salt, and pepper together in a bowl.
2. In your air fryer, add broccoli, carrots, and tomatoes.
3. Sprinkle cheddar cheese on top, add the egg mixture, cover, and cook at 175°C for 20 minutes.
4. Divide among plates and serve.

Butter Eggs

Prep Time: 10 Min | Cook Time: 12 Min | Serves: 4

Calories: 260.1 | Fat: 5.1g | Carbs: 12.0g | Protein: 5.1g

INGREDIENTS

- 2 tsp butter, soft
- 2 ham slices
- 4 eggs
- 2 tbsp heavy cream
- Salt and black pepper to the taste
- 3 tbsp parmesan, grated
- 2 tsp chives, chopped
- A pinch of smoked paprika

DIRECTIONS

1. Butter the pan of your air fryer, line it with the ham, and place it in the basket of your air fryer.
2. Add ham to a bowl and whisk together 1 egg, heavy cream, salt, and pepper.
3. Add the remaining eggs to the pan, top with parmesan, and cook the mixture for 12 minutes at 160°C.
4. Sprinkle the paprika and chives evenly among the plates and serve as breakfast.

Cheesy Breakfast Bread

Prep Time: 10 Min | Cook Time: 8 Min | Serves: 3

Calories: 185.1 | Fat: 5.1g | Carbs: 8.0g | Protein: 3.1g

INGREDIENTS

- 6 bread slices
- 5 tbsp butter, melted
- 3 garlic cloves, minced
- 6 tsp sun dried tomato pesto
- 250g mozzarella cheese, grated

DIRECTIONS

1. Lay down the slices of bread on the work surface.
2. Cover with butter, divide tomato paste and garlic, and sprinkle grated cheese on top.
3. Place bread pieces in your preheated air fryer and cook them for 8 minutes at 175°C.
4. Distribute among serving plates and provide as breakfast.

Breakfast Bread Pudding

Prep Time: 10 Min | Cook Time: 22 Min | Serves: 4

Calories: 260.1 | Fat: 7.1g | Carbs: 8.0g | Protein: 5.1g

INGREDIENTS

- 250g white bread, cubed
- 400ml milk
- 400ml water
- 2 tsp cornstarch
- 125g apple, peeled, cored and roughly chopped
- 5 tbsp honey
- 1 tsp vanilla extract
- 2 tsp cinnamon powder
- 250g and 150g flour
- 150g brown sugar
- 85g soft butter

DIRECTIONS

1. Mix the bread, the apple, the milk, the water, the honey, the cinnamon, the vanilla, and the cornstarch thoroughly in a bowl.
2. Combine flour, sugar, and butter in a separate bowl and whisk until the mixture resembles coarse crumbs.
3. Press half of the crumble mixture into the bottom of the air fryer, add the bread and apple mixture, top with the remaining crumble mixture, and cook for 22 minutes at 175°C.
4. Serve and enjoy!

Buttermilk Breakfast Biscuits

Prep Time: 10 Min | Cook Time: 8 Min | Serves: 4

Calories: 190.1 | Fat: 6.1g | Carbs: 12.0g | Protein: 3.1g

INGREDIENTS

- 300g white flour
- 125g self-rising flour
- ¼ tsp baking soda
- ½ tsp baking powder
- 1 tsp sugar
- 4 tbsp butter, cold and cubed+ 1 tbsp melted butter
- 180ml buttermilk
- Maple syrup for serving

DIRECTIONS

1. White flour, self-rising flour, baking soda, baking powder, and sugar are combined in a bowl and stirred.
2. Use your hands to mix in the chilled butter.
3. Add the buttermilk, whisk to form a dough, then place the dough on a floured work surface.
4. Using a circular cutter, roll your dough and cut it into 10 pieces.
5. Arrange biscuits in the cake pan of the air fryer, spray them with melted butter, and cook for 8 minutes at 200°C.
6. Place some maple syrup on top and serve for breakfast.

Spanish Omelet

Prep Time: 10 Min | Cook Time: 10 Min | Serves: 4

Calories: 299.1 | Fat: 6.1g | Carbs: 12.0g | Protein: 6.1g

INGREDIENTS

- 3 eggs
- ½ chorizo, chopped
- 1 potato, peeled and cubed
- 125g corn
- 1 tbsp olive oil
- 1 tbsp parsley, chopped
- 1 tbsp feta cheese, crumbled
- Salt and black pepper to the taste

DIRECTIONS

1. Add oil to your air fryer and preheat it to 175°C.
2. Stir in the potatoes and chorizo before quickly browning both ingredients.
3. Whisk eggs, corn, parsley, cheese, salt, and pepper together in a bowl.
4. Spread this out and cook the chorizo and potatoes for 5 minutes.
5. Serve and enjoy!

Breakfast Bread Rolls

Prep Time: 10 Min | Cook Time: 12 Min | Serves: 4

Calories: 259.1 | Fat: 6.1g | Carbs: 12.0g | Protein: 7.1g

INGREDIENTS

- 5 potatoes, boiled, peeled and mashed
- 8 bread slices, white parts only
- 1 coriander bunch, chopped
- 2 green chilies, chopped
- 2 small yellow onions, chopped
- ½ tsp turmeric powder
- 2 curry leaf springs
- ½ tsp mustard seeds
- 2 tbsp olive oil
- Salt and black pepper to the taste

DIRECTIONS

1. One tsp of oil is heated in a pan. Mustard seeds, onions, curry leaves, and turmeric are added, and they are stirred and cooked for a short time.
2. Remove from fire and toss in the mashed potatoes, salt, pepper, coriander, and chilies.
3. Use wet hands to form eight equal portions of the potato mixture into ovals.
4. Wet a slice of bread with water, press it to remove excess moisture, and hold it in your palm.
5. Place an oval of potato on top of the slice of bread and round it.
6. Repeat with the remaining bread and potato mixture.
7. Heat the remaining oil in your air fryer to 200°C. Add the bread rolls and cook them for 12 minutes.
8. Serve and enjoy!

Egg White Omelet

Prep Time: 10 Min | Cook Time: 15 Min | Serves: 4

Calories: 100.1 | Fat: 3.1g | Carbs: 7.0g | Protein: 4.1g

INGREDIENTS

- 250ml egg whites
- 60g tomato, chopped
- 2 tbsp skim milk
- 60g mushrooms, chopped
- 2 tbsp chives, chopped
- Salt and black pepper to the taste

DIRECTIONS

1. Egg whites should be combined with tomato, milk, mushrooms, chives, salt, and pepper in a bowl before being poured into the pan of your air fryer.
2. Cook at 160°C for 15 minutes, cool omelet down, slice, divide among plates and serve.

Artichoke Frittata

Prep Time: 10 Min | Cook Time: 15 Min | Serves: 6

Calories: 134.2 | Fat: 6.1g | Carbs: 9.0g | Protein: 4.1g

INGREDIENTS

- 3 canned artichokes hearts, drained and chopped
- 2 tbsp olive oil
- ½ tsp oregano, dried
- Salt and black pepper to the taste
- 6 eggs, whisked

DIRECTIONS

1. Whisk the eggs well and combine the artichokes with the oregano, salt, and pepper in a bowl.
2. Pour oil into the air fryer's pan, add the egg mixture, and cook for 15 minutes at 160°C.
3. Serve and enjoy!

Breakfast Beef Burger

Prep Time: 10 Min | Cook Time: 45 Min | Serves: 4

Calories: 231.2 | Fat: 5.1g | Carbs: 12.0g | Protein: 4.1g

INGREDIENTS

- ½ kg beef, ground
- 1 yellow onion, chopped
- 1 tsp tomato puree
- 1 tsp garlic, minced
- 1 tsp mustard
- 1 tsp basil, dried
- 1 tsp parsley, chopped
- 1 tbsp cheddar cheese, grated
- Salt and black pepper to the taste
- 4 bread buns, for serving

DIRECTIONS

1. Combine the meat, onion, tomato puree, garlic, mustard, basil, parsley, cheese, salt, and pepper in a bowl. Stir well. Form the mixture into 4 patties.
2. Place the burgers in the air fryer and heat it to 200°C for 25 minutes.
3. Lower the heat to 175°C and bake the burgers for an additional 20 minutes.
4. Serve them as a quick breakfast by placing them on bread buns.

LUNCH RECIPES

Chicken Kabobs

Prep Time: 10 Min | Cook Time: 20 Min | Serves: 2

Calories: 259.2 | Fat: 7.1g | Carbs: 12.0g | Protein: 6.1g

INGREDIENTS

- 3 orange bell peppers, cut into squares
- 60ml honey
- 100ml soy sauce
- Salt and black pepper to the taste
- Cooking spray
- 6 mushrooms, halved
- 2 chicken breasts, skinless, boneless and roughly cubed

DIRECTIONS

1. Chicken should be combined with cooking spray, honey, salt, pepper, and a jar of sauce in a bowl.
2. Skewer chicken, bell peppers, and mushrooms and cook them in your air fryer for 20 minutes at 170°C.
3. Serve and enjoy!

Turkish Koftas

Prep Time: 10 Min | Cook Time: 15 Min | Serves: 2

Calories: 281.2 | Fat: 7.1g | Carbs: 17.0g | Protein: 6.1g

INGREDIENTS

- 1 leek, chopped
- 2 tbsp feta cheese, crumbled
- 250g lean beef, minced
- 1 tbsp cumin, ground
- 1 tbsp mint, chopped
- 1 tbsp parsley, chopped
- 1 tsp garlic, minced
- Salt and black pepper to the taste

DIRECTIONS

1. Stir the meat, leek, cheese, cumin, mint, parsley, salt, and pepper in a bowl until well combined. Form the mixture into koftas and arrange them on sticks.
2. Place the koftas in the preheated air fryer and cook them for 15 minutes at 180°C.
3. Serve them with a side salad for lunch.

Chinese Pork Lunch Mix

Prep Time: 10 Min | Cook Time: 12 Min | Serves: 4

Calories: 319.2 | Fat: 8.1g | Carbs: 20.0g | Protein: 5.1g

INGREDIENTS

- 2 eggs
- 1 kg pork, cut into medium cubes
- 250g cornstarch
- 1 tsp sesame oil
- Salt and black pepper to the taste
- A pinch of Chinese five spice
- 3 tbsp canola oil
- Sweet tomato sauce for serving

DIRECTIONS

1. Stir together cornstarch, salt, and five spice in a bowl.
2. Whisk the eggs and sesame oil together in a separate bowl.
3. Place the pork cubes in your oiled air fryer after dredging them in cornstarch mixture, egg mixture, and cornstarch mixture.
4. Cook for 12 minutes while shaking the fryer at 170°C.
5. Put the sweet tomato sauce on the side and serve the pork for lunch.

Beef Lunch Meatballs

Prep Time: 10 Min | Cook Time: 15 Min | Serves: 4

Calories: 332.2 | Fat: 22.1g | Carbs: 8.0g | Protein: 20.1g

INGREDIENTS

- 250g beef, ground
- 250g Italian sausage, chopped
- ½ tsp garlic powder
- ½ tsp onion powder
- Salt and black pepper to the taste
- 120g cheddar cheese, grated
- Mashed potatoes for serving

DIRECTIONS

1. Beef, sausage, cheese, garlic powder, onion powder, salt, and pepper should all be combined in a bowl. From this mixture, 16 meatballs should be formed.
2. Put the meatballs in your air fryer and cook them for 15 minutes at 185°C
3. Put some mashed potatoes on the side and serve your meatballs with them.

Prosciutto Sandwich

Prep Time: 10 Min | Cook Time: 5 Min | Serves: 1

Calories: 171.2 | Fat: 3.1g | Carbs: 9.0g | Protein: 5.1g

INGREDIENTS

- 2 bread slices
- 2 mozzarella slices
- 2 tomato slices
- 2 prosciutto slices
- 2 basil leaves
- 1 tsp olive oil
- A pinch of salt and black pepper

DIRECTIONS

1. Put cheese and prosciutto on a piece of bread.
2. Place in your air fryer and season with salt & pepper. Cook for 5 minutes at 200°C.
3. Drizzle oil over the prosciutto, then top with the tomato and basil. Finally, top with the remaining piece of bread, cut in half, and serve.

Japanese Chicken Mix

Prep Time: 10 Min | Cook Time: 8 Min | Serves: 2

Calories: 298.4 | Fat: 7.1g | Carbs: 17.0g | Protein: 10.1g

INGREDIENTS

- 2 chicken thighs, skinless and boneless
- 2 ginger slices, chopped
- 3 garlic cloves, minced
- 60ml soy sauce
- 60ml mirin
- 30g sake
- ½ tsp sesame oil
- 30ml water
- 2 tbsp sugar
- 1 tbsp cornstarch mixed with 2 tbsp water
- Sesame seeds for serving

DIRECTIONS

1. Chicken thighs should be combined with ginger, garlic, soy sauce, mirin, sake, oil, water, sugar, and cornstarch in a bowl. After well mixing, the chicken should be transferred to a prepared air fryer and cooked at 180°C for 8 minutes.
2. To serve with a side salad for lunch, divide among plates, garnish with sesame seeds, and serve.

Lentils Fritters

Prep Time: 10 Min | Cook Time: 10 Min | Serves: 2

Calories: 141.4 | Fat: 2.1g | Carbs: 12.0g | Protein: 4.1g

INGREDIENTS

- 250g yellow lentils, soaked in water for 1 hour and drained
- 1 hot chili pepper, chopped
- 1 inch ginger piece, grated
- ½ tsp turmeric powder
- 1 tsp garam masala
- 1 tsp baking powder
- Salt and black pepper to the taste
- 2 tsp olive oil
- 75ml water
- 125g cilantro, chopped
- 375g spinach, chopped
- 4 garlic cloves, minced
- 180g red onion, chopped
- Mint chutney for serving

DIRECTIONS

1. Blend lentils with chili pepper, ginger, turmeric, garam masala, baking powder, salt, pepper, olive oil, water, spinach, onion, and garlic until smooth. Then, scoop out a medium amount of the mixture and roll it into balls.
2. Put them all in the air fryer that has been prepared to 200°C and cook them for 10 minutes.
3. For lunch, serve your vegetarian fritters with a side salad.

Potato Salad

Prep Time: 10 Min | Cook Time: 25 Min | Serves: 4

Calories: 210.4 | Fat: 6.1g | Carbs: 12.0g | Protein: 4.1g

INGREDIENTS

- 1 kg red potatoes, halved
- 2 tbsp olive oil
- Salt and black pepper to the taste
- 2 green onions, chopped
- 1 red bell pepper, chopped
- 80ml lemon juice
- 3 tbsp mustard

DIRECTIONS

1. Mix potatoes in the basket of your air fryer with half the olive oil, salt, and pepper, and cook for 25 minutes at 175°C, shaking the frying once.
2. Combine onions, bell pepper, and roasted potatoes in a bowl and toss to combine.
3. Combine the remaining oil and mustard with the lemon juice in a small bowl and whisk vigorously.
4. Combine this with the potato salad, then serve it for lunch.

Corn Casserole

Prep Time: 10 Min | Cook Time: 15 Min | Serves: 4

Calories: 281.4 | Fat: 7.1g | Carbs: 9.0g | Protein: 6.1g

INGREDIENTS

- 500g corn
- 3 tbsp flour
- 1 egg
- 60ml milk
- 125ml light cream
- 125g Swiss cheese, grated
- 2 tbsp butter
- Salt and black pepper to the taste
- Cooking spray

DIRECTIONS

1. Corn, flour, egg, milk, light cream, cheese, salt, pepper, and butter should all be combined together in a bowl.
2. Spray cooking spray on the pan of your air fryer, add the cream mixture, spread it out, and cook for 15 minutes at 160°C.

Bacon and Garlic Pizzas

Prep Time: 10 Min | Cook Time: 10 Min | Serves: 4

Calories: 216.4 | Fat: 5.1g | Carbs: 12.0g | Protein: 4.1g

INGREDIENTS

- 4 dinner rolls, frozen
- 4 garlic cloves minced
- ½ tsp oregano dried
- ½ tsp garlic powder
- 250ml tomato sauce
- 8 bacon slices, cooked and chopped
- 350g cheddar cheese, grated
- Cooking spray

DIRECTIONS

1. Dinner rolls should be placed on a work area and pressed to create four ovals.
2. Cook each oval in your air fryer for 2 minutes at 185°C after spraying it with cooking spray.
3. Cover each oval with tomato sauce, split the garlic, add oregano and garlic powder, and then top with bacon and cheese.
4. Place the pizzas back in the hot air fryer and cook them for an additional 8 minutes at 185°C
5. Serve them warm for lunch.

Sweet and Sour Sausage Mix

Prep Time: 10 Min | Cook Time: 10 Min | Serves: 4

Calories: 161.4 | Fat: 6.1g | Carbs: 12.0g | Protein: 6.1g

INGREDIENTS

- ½ kg sausages, sliced
- 1 red bell pepper, cut into strips
- 125g yellow onion, chopped
- 3 tbsp brown sugar
- 80ml ketchup
- 2 tbsp mustard
- 2 tbsp apple cider vinegar
- 125ml chicken stock

DIRECTIONS

1. Whisk sugar, ketchup, mustard, stock, and vinegar together in a bowl.
2. Toss sausage pieces with bell pepper, onion, and sweet-and-sour sauce in the pan of your air fryer. Cook for 10 minutes at 175°C.
3. Serve and enjoy!

Meatballs and Tomato Sauce

Prep Time: 10 Min | Cook Time: 15 Min | Serves: 4

Calories: 298.4 | Fat: 8.1g | Carbs: 16.0g | Protein: 5.1g

INGREDIENTS

- ½ kg lean beef, ground
- 3 green onions, chopped
- 2 garlic cloves, minced
- 1 egg yolk
- 60g bread crumbs
- Salt and black pepper to the taste
- 1 tbsp olive oil
- 450ml tomato sauce
- 2 tbsp mustard

DIRECTIONS

1. Beef, onion, garlic, egg yolk, bread crumbs, salt, and pepper should all be combined in a bowl. The mixture should then be formed into medium meatballs.
2. Place the meatballs in the air fryer and cook for 10 minutes at 200°C. Grease the meatballs with the oil.
3. Combine tomato sauce and mustard in a bowl, stir, add the meatballs, combine them, and cook at 200°Cahrenheit for an additional 5 minutes.
4. To serve for lunch, divide the meatballs and sauce among plates.

Steak and Cabbage

Prep Time: 10 Min | Cook Time: 10 Min | Serves: 4

Calories: 281.4 | Fat: 6.1g | Carbs: 14.0g | Protein: 6.1g

INGREDIENTS

- ¼ kg sirloin steak, cut into strips
- 2 tsp cornstarch
- 1 tbsp peanut oil
- 450g green cabbage, chopped
- 1 yellow bell pepper, chopped
- 2 green onions, chopped
- 2 garlic cloves, minced
- Salt and black pepper to the taste

DIRECTIONS

1. Cabbage should be combined with salt, pepper, and peanut oil in a bowl, then placed in the air fryer basket and cooked for 4 minutes at 185°C before being transferred to a bowl.
2. Cook steak strips in your air fryer for 5 minutes after adding green onions, bell peppers, garlic, salt, and pepper.
3. Add the cabbage and combine. Then divide the mixture among plates and serve as lunch.

Stuffed Meatballs

Prep Time: 10 Min | Cook Time: 10 Min | Serves: 4

Calories: 198.4 | Fat: 5.1g | Carbs: 12.0g | Protein: 5.1g

INGREDIENTS

- 80g bread crumbs
- 3 tbsp milk
- 1 tbsp ketchup
- 1 egg
- ½ tsp marjoram, dried
- Salt and black pepper to the taste
- ½ kg lean beef, ground
- 20 cheddar cheese cubes
- 1 tbsp olive oil

DIRECTIONS

1. Bread crumbs should be combined with ketchup, milk, marjoram, salt, pepper, and egg in a bowl.
2. Stir in the beef, then use this mixture to form 20 meatballs.
3. Roll each meatball around a cheese cube before rubbing in the oil.
4. Put all of the meatballs in the prepared air fryer and cook for 10 minutes at 195°C.
5. Serve them for lunch with a side salad.

Turkey Breast

Prep Time: 10 Min | Cook Time: 45 Min | Serves: 4

Calories: 279.4 | Fat: 2.1g | Carbs: 16.0g | Protein: 14.1g

INGREDIENTS

- 1 big turkey breast
- 2 tsp olive oil
- ½ tsp smoked paprika
- 1 tsp thyme, dried
- ½ tsp sage, dried
- Salt and black pepper to the taste
- 2 tbsp mustard
- 60ml maple syrup
- 1 tbsp butter, soft

DIRECTIONS

1. Using the basket of your air fryer, lay the turkey breast, brush with olive oil, season with salt, pepper, thyme, paprika, and sage, and cook for 25 minutes at 175°C.
2. Flip the turkey, cook it for an additional 10 minutes, then flip it once more.
3. In the meantime, melt the butter in a skillet over medium heat. Stir in the mustard and maple syrup, cook for a couple of minutes, and then turn off the heat.
4. Slice the turkey breast, divide it among plates, and spread the maple glaze over everything before serving.

DINNER RECIPES

Crispy Lamb

Prep Time: 10 Min | Cook Time: 30 Min | Serves: 4

Calories: 230.4 | Fat: 2.1g | Carbs: 10.0g | Protein: 12.1g

INGREDIENTS

- 1 tbsp bread crumbs
- 2 tbsp macadamia nuts, toasted and crushed
- 1 tbsp olive oil
- 1 garlic clove, minced
- 800g rack of lamb
- Salt and black pepper to the taste
- 1 egg,
- 1 tbsp rosemary, chopped

DIRECTIONS

1. Oil and garlic should be thoroughly combined in a bowl.
2. Rub some oil on the meat and season it with salt and pepper.
3. Combine nuts, breadcrumbs, and rosemary in a separate bowl.
4. Place the egg in another bowl and whisk it thoroughly.
5. Place the lamb in the basket of your air fryer, coat with egg, then coat with macadamia mixture. Cook for 25 minutes at 180°C, then increase heat to 200°C and cook for 5 minutes more.

Creamy Chicken with Rice and Peas

Prep Time: 10 Min | Cook Time: 30 Min | Serves: 4

Calories: 312.4 | Fat: 12.1g | Carbs: 27.0g | Protein: 43.1g

INGREDIENTS

- ½ kg chicken breasts, skinless, boneless and cut into quarters
- 250g white rice, already cooked
- Salt and black pepper to the taste
- 1 tbsp olive oil
- 3 garlic cloves, minced
- 1 yellow onion, chopped
- 125ml white wine
- 60ml heavy cream
- 250ml chicken stock
- 60g parsley, chopped
- 450g peas, frozen
- 350g parmesan, grated

DIRECTIONS

1. Chicken breasts should be salted and peppered, then placed in the basket of your air fryer and cooked for 6 minutes at 180°C with half the oil drizzled over them.
2. Heat the remaining oil in a skillet over medium-high heat. Add the garlic, onion, wine, stock, salt, and pepper. Stir. After the mixture comes to a simmer, cook the mixture for 9 minutes.
3. Place the chicken breasts in a heat-resistant dish that fits your air fryer, top with the peas, rice, and cream mixture, toss, and then sprinkle with parmesan and parsley. Cook the chicken for 10 minutes at 210°C.

Asian Salmon

Prep Time: 1 Hr | Cook Time: 15 Min | Serves: 2

Calories: 299.4 | Fat: 12.1g | Carbs: 13.0g | Protein: 24.1g

INGREDIENTS

- 2 medium salmon fillets
- 6 tbsp light soy sauce
- 3 tsp mirin
- 1 tsp water
- 6 tbsp honey

DIRECTIONS

1. Salmon should be added to a bowl containing a mixture of soy sauce, honey, water, and mirin; whisk well; then add the salmon; rub well; and chill for an hour.
2. Place the salmon in the air fryer, flipping it over after 7 minutes, and cook for 15 minutes at 180°C.
3. In the meantime, heat up the soy marinade in a pan over medium heat, stir it well, cook for 2 minutes, and then turn off the heat.
4. Distribute the salmon among plates, top with marinade, and serve.

Beef Fillets with Garlic Mayo

Prep Time: 10 Min | Cook Time: 40 Min | Serves: 8

Calories: 400.4 | Fat: 12.1g | Carbs: 27.0g | Protein: 19.1g

INGREDIENTS

- 250g mayonnaise
- 80ml sour cream
- 2 garlic cloves, minced
- 1 ½ kg beef fillet
- 2 tbsp chives, chopped
- 2 tbsp mustard
- 2 tbsp mustard
- 60g tarragon, chopped
- Salt and black pepper to the taste

DIRECTIONS

1. Season beef with salt and pepper to the taste, place in your air fryer, cook at 185°C for 20 minutes, transfer to a plate and leave aside for a few minutes.
2. Combine the garlic, sour cream, chives, mayonnaise, salt, and pepper in a bowl. Whisk to combine.
3. Return the beef to the air fryer and cook at 175°C for an additional 20 minutes by combining mustard, Dijon mustard, and tarragon in another bowl, whisking in the mixture as you go.
4. Distribute the meat among the dishes, sprinkle with the garlic mayo, and serve.

Cod Steaks with Plum Sauce

Prep Time: 10 Min | Cook Time: 20 Min | Serves: 2

Calories: 249.4 | Fat: 7.1g | Carbs: 14.0g | Protein: 12.1g

INGREDIENTS

- 2 big cod steaks
- Salt and black pepper to the taste
- ½ tsp garlic powder
- ½ tsp ginger powder
- ¼ tsp turmeric powder
- 1 tbsp plum sauce
- Cooking spray

DIRECTIONS

1. Cod steaks are seasoned with salt and pepper, cooking oil, garlic powder, ginger powder, and turmeric powder. They are then thoroughly rubbed.
2. Put the cod steaks in the air fryer and cook them for 15 minutes at 180°Cahrenheit, flipping them over after 7 minutes.
3. Plunge a pan into heat, add plum sauce, and cook for two minutes while stirring.
4. Arrange the fish steaks on the dishes, top with plum sauce, and serve.

Honey Duck Breasts

Prep Time: 10 Min | Cook Time: 20 Min | Serves: 2

Calories: 274.4 | Fat: 11.1g | Carbs: 22.0g | Protein: 13.1g

INGREDIENTS

- 1 smoked duck breast, halved
- 1 tsp honey
- 1 tsp tomato paste
- 1 tbsp mustard
- ½ tsp apple vinegar

DIRECTIONS

1. Duck breast pieces should be added to a bowl with the honey mixture, tomato paste, mustard, and vinegar, whisked well. After well-coating, move the duck to your air fryer, and cook for 15 minutes at 185°C
2. Remove the duck breast from the air fryer, add the honey mixture, toss once more, and cook at 185°C for an additional 6 minutes.
3. Distribute between plates and offer a side salad.

Lamb and Creamy Brussels Sprouts

Prep Time: 10 Min | Cook Time: 1 Hr 10 Min | Serves: 4

Calories: 430.4 | Fat: 22.1g | Carbs: 2.0g | Protein: 48.1g

INGREDIENTS

- 1 kg leg of lamb, scored
- 2 tbsp olive oil
- 1 tbsp rosemary, chopped
- 1 tbsp lemon thyme, chopped
- 1 garlic clove, minced
- 750g Brussels sprouts, trimmed
- 1 tbsp butter, melted
- 125ml sour cream
- Salt and black pepper to the taste

DIRECTIONS

1. Leg of lamb is seasoned with salt, pepper, thyme, and rosemary, placed in the basket of your air fryer, and cooked at 150°C for one hour before being transferred to a platter and kept warm.
2. Combine Brussels sprouts with salt, pepper, garlic, butter, and sour cream in a pan that will fit your air fryer. Toss, then cook for 10 minutes at 200°C.
3. Distribute the lamb among plates and serve with the Brussels sprouts on the side.

Italian Chicken

Prep Time: 10 Min | Cook Time: 15 Min | Serves: 4

Calories: 271.4 | Fat: 9.1g | Carbs: 37.0g | Protein: 23.1g

INGREDIENTS

- 5 chicken thighs
- 1 tbsp olive oil
- 2 garlic cloves, minced
- 1 tbsp thyme, chopped
- 125ml heavy cream
- 180ml chicken stock
- 1 tsp red pepper flakes, crushed
- 60g parmesan, grated
- 125g sun dried tomatoes
- 2 tbsp basil, chopped
- Salt and black pepper to the taste

DIRECTIONS

1. Chicken should be salted and peppered, rubbed with half the oil, and cooked for 4 minutes at 175°C in an air fryer that has been prepared.
2. In the meantime, heat the remaining oil in a skillet over medium-high heat. Add the thyme, garlic, pepper flakes, sun-dried tomatoes, heavy cream, stock, parmesan, salt, and pepper. Stir, then reduce the heat to a simmer. Remove from the heat, and transfer to a dish that will fit your air fryer.
3. Place the chicken thighs on top and cook for 12 minutes at 160°Cahrenheit in your air fryer.
4. Distribute among dishes and garnish with basil.

Mustard Marinated Beef

Prep Time: 10 Min | Cook Time: 45 Min | Serves: 6

Calories: 481.4 | Fat: 9.1g | Carbs: 29.0g | Protein: 35.1g

INGREDIENTS

- 6 bacon strips
- 2 tbsp butter
- 3 garlic cloves, minced
- Salt and black pepper to the taste
- 1 tbsp horseradish
- 1 tbsp mustard
- 1 ½ kg beef roast
- 450ml beef stock
- 80ml red wine

DIRECTIONS

1. Rub the meat with a mixture made by whisking together the butter, horseradish, mustard, garlic, salt, and pepper.
2. Arrange bacon strips on a cutting board, top with beef, fold bacon around beef, move to the basket of your air fryer, cook for 15 minutes at 200°C, and then transfer to a pan that will fit your fryer.
3. Put the pan in the air fryer, add the stock and wine, and cook the beef for an additional 30 minutes at 180°C.
4. Slice the steak and serve it with a side salad.

Lemon Soy Salmon

Prep Time: 1 Hr | Cook Time: 20 Min | Serves: 2

Calories: 300.4 | Fat: 12.1g | Carbs: 23.0g | Protein: 20.1g

INGREDIENTS

- 2 salmon fillets
- 2 tbsp lemon juice
- Salt and black pepper to the taste
- ½ tsp garlic powder
- 80ml water
- 80ml soy sauce
- 3 scallions, chopped
- 75g brown sugar
- 2 tbsp olive oil

DIRECTIONS

1. Salmon fillets should be added to a bowl that has already been prepared with sugar, water, soy sauce, garlic powder, salt, pepper, oil, and lemon juice. Whisk to combine, then toss to coat. Refrigerate for one hour.
2. Add salmon fillets to the fryer's basket and cook for 8 minutes at 180°C, rotating them halfway through.
3. Distribute the salmon among plates, garnish with scallions, and serve immediately.

Salmon with Capers and Mash

Prep Time: 10 Min | Cook Time: 20 Min | Serves: 4

Calories: 300.4 | Fat: 17.1g | Carbs: 12.0g | Protein: 18.1g

INGREDIENTS

- 4 salmon fillets, skinless and boneless
- 1 tbsp capers, drained
- Salt and black pepper to the taste
- Juice from 1 lemon
- 2 tsp olive oil

For the potato mash:

- 2 tbsp olive oil
- 1 tbsp dill, dried
- ½ kg potatoes, chopped
- 125ml milk

DIRECTIONS

1. Place potatoes in a saucepan, cover with water, add salt, bring to a boil over medium-high heat, cook for 15 minutes, drain, transfer to a bowl, mash with a potato masher, add 2 tbsp oil, dill, salt, and pepper, stir well, and set aside for the time being.
2. Season the salmon with salt and pepper, rub in 2 tbsp of oil, place in the basket of your air fryer, sprinkle with capers, and cook for 8 minutes at 180°C.
3. Place the salmon and capers on individual dishes, top with mashed potatoes and a squeeze of lemon juice, and then serve.

Chinese Duck Legs

Prep Time: 10 Min | Cook Time: 35 Min | Serves: 2

Calories: 300.4 | Fat: 12.1g | Carbs: 26.0g | Protein: 18.1g

INGREDIENTS

- 2 duck legs
- 2 dried chilies, chopped
- 1 tbsp olive oil
- 2 star anise
- 1 bunch spring onions, chopped
- 4 ginger slices
- 1 tbsp oyster sauce
- 1 tbsp soy sauce
- 1 tsp sesame oil
- 400ml water
- 1 tbsp rice wine

DIRECTIONS

1. Over medium-high heat, add the oil to a skillet along with the chile, star anise, rice wine, ginger, oyster sauce, soy sauce, and water. Stir and cook for 6 minutes.
2. Add the spring onions and duck legs, mix to combine, then transfer to a pan that fits in your air fryer. Cook for 30 minutes at 185°C

Red Indian Pork

Prep Time: 35 Min | Cook Time: 10 Min | Serves: 4

Calories: 420.4 | Fat: 11.1g | Carbs: 42.0g | Protein: 18.1g

INGREDIENTS

- 1 tsp ginger powder
- 2 tsp chili paste
- 2 garlic cloves, minced
- 500g pork chops, cubed
- 1 shallot, chopped
- 1 tsp coriander, ground

- 200ml coconut milk
- 2 tbsp olive oil
- 80g peanuts, ground
- 3 tbsp soy sauce
- Salt and black pepper to the taste

DIRECTIONS

1. Combine ginger, 1 tsp of chili paste, half of the garlic, half of the soy sauce, and half of the oil in a bowl. Whisk in the remaining ingredients. Add the pork, toss, and set aside for 10 minutes.
2. Transfer the meat to the basket of your air fryer, and cook for 12 minutes at 200°C, flipping the meat once.
3. In the meantime, heat the remaining oil in a skillet over medium-high heat. Add the shallot, remaining garlic, coriander, coconut milk, remaining peanuts, remaining chili paste, and remaining soy sauce. Stir and simmer for 5 minutes.
4. Distribute the coconut mixture on top of the meat and serve.

Stuffed Chicken

Prep Time: 10 Min | Cook Time: 35 Min | Serves: 8

Calories: 319.4 | Fat: 12.1g | Carbs: 22.0g | Protein: 12.1g

INGREDIENTS

- 1 whole chicken
- 10 wolfberries
- 2 red chilies, chopped
- 4 ginger slices
- 1 yam, cubed
- 1 tsp soy sauce
- Salt and white pepper to the taste
- 3 tsp sesame oil

DIRECTIONS

1. Rub soy sauce and sesame oil over chicken, season with salt and pepper, then stuff with wolfberries, yam cubes, chilies, and ginger.
2. Put the food in your air fryer and cook it for 15 minutes at 180°C and then 20 minutes at 200°C.
3. Carve the chicken, then distribute it among the dishes.

Lemony Saba Fish

Prep Time: 10 Min | Cook Time: 8 Min | Serves: 1

Calories: 300.4 | Fat: 4.1g | Carbs: 15.0g | Protein: 15.1g

INGREDIENTS

- 4 Saba fish fillet, boneless
- Salt and black pepper to the taste
- 3 red chili pepper, chopped
- 2 tbsp lemon juice
- 2 tbsp olive oil
- 2 tbsp garlic, minced

DIRECTIONS

1. Fish fillets are salted and peppered before being placed in a bowl.
2. Transfer fish to your air fryer and sprinkle with lemon juice, oil, chile, and garlic. Cook at 180°C for 8 minutes, flipping halfway through.

SNACKS RECIPES

Spring Rolls

Prep Time: 10 Min | Cook Time: 25 Min | Serves: 8

Calories: 213.4 | Fat: 4.1g | Carbs: 12.0g | Protein: 4.1g

INGREDIENTS

- 450g green cabbage, shredded
- 2 yellow onions, chopped
- 1 carrot, grated
- ½ chili pepper, minced
- 1 tbsp ginger, grated
- 3 garlic cloves, minced
- 1 tsp sugar
- Salt and black pepper to the taste
- 1 tsp soy sauce
- 2 tbsp olive oil
- 10 spring roll sheets
- 2 tbsp corn flour
- 2 tbsp water

DIRECTIONS

1. In a medium-sized skillet, heat the oil. Add the cabbage, onions, carrots, chili pepper, ginger, garlic, sugar, salt, and soy sauce. Stir well. Cook for two to three minutes. Remove from heat. Allow to cool.
2. Divide the cabbage mixture among the squares of spring roll paper before rolling each one up.
3. Combine corn flour and water in a bowl, whisk well, and use this mixture to enclose spring rolls.
4. Put spring rolls in the basket of your air fryer and fry them for 10 minutes at 180°Cahrenheit.
5. After 10 more minutes, flip the rolls over.

Crispy Radish Chips

Prep Time: 10 Min | Cook Time: 10 Min | Serves: 4

Calories: 80.4 | Fat: 1.1g | Carbs: 1.0g | Protein: 1.1g

INGREDIENTS

- Cooking spray
- 15 radishes, sliced
- Salt and black pepper to the taste
- 1 tbsp chives, chopped

DIRECTIONS

1. Slices of radish should be placed in the basket of your air fryer, sprayed with cooking oil, seasoned with salt and black pepper to taste, and cooked for 10 minutes at 175°C, flipping them halfway through.
2. They should then be transferred to bowls and served with chives sprinkled on top.

Crab Sticks

Prep Time: 10 Min | Cook Time: 12 Min | Serves: 4

Calories: 109.4 | Fat: 0.1g | Carbs: 4.0g | Protein: 2.1g

INGREDIENTS

- 10 crabsticks, halved
- 2 tsp sesame oil
- 2 tsp Cajun seasoning

DIRECTIONS

1. Crab sticks should be placed in a bowl, mixed with sesame oil and Cajun seasoning, then placed in the basket of your air fryer and cooked for 12 minutes at 175°C.
2. Serve and enjoy!

Air Fried Dill Pickles

Prep Time: 10 Min | Cook Time: 5 Min | Serves: 4

Calories: 109.4 | Fat: 2.1g | Carbs: 9.0g | Protein: 4.1g

INGREDIENTS

- 450g jarred dill pickles, cut into wedges and pat dried
- 125g white flour
- 1 egg
- 60ml milk
- ½ tsp garlic powder
- ½ tsp sweet paprika
- Cooking spray
- 60ml ranch sauce

DIRECTIONS

1. Combine milk and egg in a bowl and stir well.
2. Stir together the flour, salt, garlic powder, and paprika in a separate bowl.
3. Place pickles in the air fryer after dipping them in flour, egg mixture, and flour one more.
4. Cook pickle wedges for 5 minutes at 200°Cahrenheit with cooking spray, transfer to a bowl, and serve with ranch dressing on the side.

Chickpeas Snack

Prep Time: 10 Min | Cook Time: 10 Min | Serves: 4

Calories: 140.4 | Fat: 1.1g | Carbs: 20.0g | Protein: 6.1g

INGREDIENTS

- 430g canned chickpeas, drained
- ½ tsp cumin, ground
- 1 tbsp olive oil
- 1 tsp smoked paprika
- Salt and black pepper to the taste

DIRECTIONS

1. Chickpeas should be combined with oil, cumin, paprika, salt, and pepper in a bowl. After being coated, they should be put in the fryer basket and cooked for 10 minutes at 195°C.
2. Divide into bowls and serve as a snack.

Sausage Balls

Prep Time: 10 Min | Cook Time: 15 Min | Serves: 9

Calories: 130.4 | Fat: 7.1g | Carbs: 13.0g | Protein: 4.1g

INGREDIENTS

- 120g sausage meat, ground
- Salt and black pepper to the taste
- 1 tsp sage
- ½ tsp garlic, minced
- 1 small onion, chopped
- 3 tbsp breadcrumbs

DIRECTIONS

1. Sausage, breadcrumbs, sage, garlic, onion, and salt and pepper should be combined in a bowl. Stir well.
2. Place them in the basket of your air fryer, cook at 180°Cahrenheit for 15 minutes, then chop into bowls and offer as a snack.

Chicken Dip

Prep Time: 10 Min | Cook Time: 25 Min | Serves: 10

Calories: 239.4 | Fat: 10.1g | Carbs: 24.0g | Protein: 12.1g

INGREDIENTS

- 3 tbsp butter, melted
- 250ml yogurt
- 350ml cream cheese
- 450g chicken meat, cooked and shredded
- 2 tsp curry powder
- 4 scallions, chopped
- 175g Monterey jack cheese, grated
- 75g raisins
- 60g cilantro, chopped
- 125g almonds, sliced
- Salt and black pepper to the taste
- 125ml chutney

DIRECTIONS

1. Use your mixer to combine the cream cheese and yogurt in a bowl.
2. Add the salt, pepper, cilantro, raisins, cheese, chicken meat, curry powder, and scallions.
3. Spread this mixture onto a baking dish that fits your air fryer, cover with almonds, and bake at 150°C for 25 minutes. Then, divide the mixture into bowls, top with chutney, and serve as an appetizer.

Sweet Popcorn

Prep Time: 5 Min | Cook Time: 10 Min | Serves: 4

Calories: 70.4 | Fat: 0.1g | Carbs: 1.0g | Protein: 1.1g

INGREDIENTS

- 2 tbsp corn kernels
- 2 and ½ tbsp butter
- 50g brown sugar

DIRECTIONS

1. Corn kernels should be placed in the pan of your air fryer, cooked at 200°C for 6 minutes, then moved to a tray, spread out, and set aside for the time being.
2. Put a pan on the stovetop over low heat, add the butter, and melt it. Then, add the sugar and stir until it dissolves.
3. Add the popcorn, mix it up, turn off the heat, and spread it out once more on the tray.
4. Allow to cool, divide, and serve as a snack.

Apple Chips

Prep Time: 10 Min | Cook Time: 10 Min | Serves: 2

Calories: 70.4 | Fat: 0.1g | Carbs: 3.0g | Protein: 1.0g

INGREDIENTS

- 1 apple, cored and sliced
- A pinch of salt
- ½ tsp cinnamon powder
- 1 tbsp white sugar

DIRECTIONS

1. Apple slices should be combined with salt, sugar, and cinnamon in a bowl before being transferred to the basket of your air fryer and cooked for 10 minutes at 195°C, flipping once.
2. To serve as a snack, distribute apple chips among bowls.

Bread Sticks

Prep Time: 10 Min | Cook Time: 10 Min | Serves: 2

Calories: 139.4 | Fat: 1.1g | Carbs: 8.0g | Protein: 4.0g

INGREDIENTS

- 4 bread slices, each cut into 4 sticks
- 2 eggs
- 60ml milk
- 1 tsp cinnamon powder
- 1 tbsp honey
- 60g brown sugar
- A pinch of nutmeg

DIRECTIONS

1. Whisk the eggs, milk, brown sugar, cinnamon, nutmeg, and honey together in a bowl.
2. Dip the bread sticks in this mixture, put them in the basket of your air fryer, and cook for 10 minutes at 180°C.
3. Arrange bowls with bread sticks as a snack.

Crispy Shrimp Snack

Prep Time: 10 Min | Cook Time: 5 Min | Serves: 4

Calories: 140.4 | Fat: 4.1g | Carbs: 3.0g | Protein: 4.0g

INGREDIENTS

- 12 big shrimp, deveined and peeled
- 2 egg whites
- 250g coconut, shredded
- 250g panko bread crumbs
- 250g white flour
- Salt and black pepper to the taste

DIRECTIONS

1. Panko and coconut are combined in a bowl and stirred.
2. Place egg whites in a third bowl and add flour, salt, and pepper to the second.
3. Place the shrimp in the basket of your air fryer, dredge them in flour, egg white mixture, and coconut, and cook for 10 minutes at 175°C, flipping halfway through.

Cajun Shrimp Appetizer

Prep Time: 10 Min | Cook Time: 5 Min | Serves: 2

Calories: 162.4 | Fat: 4.1g | Carbs: 8.0g | Protein: 14.0g

INGREDIENTS

- 20 tiger shrimp, peeled and deveined
- Salt and black pepper to the taste
- ½ tsp old bay seasoning
- 1 tbsp olive oil
- ¼ tsp smoked paprika

DIRECTIONS

1. Shrimp, oil, salt, pepper, old bay seasoning, and paprika should be combined in a bowl and coated.
2. Put the shrimp in the basket of your air fryer and cook for 5 minutes at 195°C.

Fish Nuggets

Prep Time: 10 Min | Cook Time: 12 Min | Serves: 4

Calories: 331.4 | Fat: 12.1g | Carbs: 17.0g | Protein: 15.0g

INGREDIENTS

- 800g fish fillets, skinless and cut into medium pieces
- Salt and black pepper to the taste
- 5 tbsp flour
- 1 egg, whisked
- 5 tbsp water
- 80g panko bread crumbs
- 1 tbsp garlic powder
- 1 tbsp smoked paprika
- 4 tbsp homemade mayonnaise
- Lemon juice from ½ lemon
- 1 tsp dill, dried
- Cooking spray

DIRECTIONS

1. Mix the flour and water thoroughly in a bowl.
2. Whisk well after adding the egg, salt, and pepper.
3. Combine panko, paprika, and garlic powder in a separate bowl.
4. Place the fish pieces in the basket of your air fryer, spray the basket with cooking oil, and fry the fish for 12 minutes at 200°Cahrenheit.
5. In the meantime, thoroughly whisk the mayo, dill, and lemon juice in a bowl.
6. Place the fish nuggets on a plate and top with dill mayo.

Crispy Fish Sticks

Prep Time: 10 Min | Cook Time: 12 Min | Serves: 2

Calories: 160.4 | Fat: 3.1g | Carbs: 12.0g | Protein: 3.0g

INGREDIENTS

- 100g bread crumbs
- 4 tbsp olive oil
- 1 egg, whisked
- 4 white fish filets, boneless, skinless and cut into medium sticks
- Salt and black pepper to the taste

DIRECTIONS

1. Oil and bread crumbs should be thoroughly combined in a bowl.
2. Add salt and pepper to the egg in the second bowl and whisk to combine.
3. Place the fish sticks in the basket of your air fryer and cook for 12 minutes at 180°C after dipping them in egg and then in bread crumbs.

Shrimp and Chestnut Rolls

Prep Time: 10 Min | Cook Time: 15 Min | Serves: 4

Calories: 139.4 | Fat: 3.1g | Carbs: 12.0g | Protein: 3.0g

INGREDIENTS

- ¼ kg already cooked shrimp, chopped
- 230g water chestnuts, chopped
- 250g shiitake mushrooms, chopped
- 450g cabbage, chopped
- 2 tbsp olive oil
- 1 garlic clove, minced
- 1 tsp ginger, grated
- 3 scallions, chopped
- Salt and black pepper to the taste
- 1 tbsp water
- 1 egg yolk
- 6 spring roll wrappers

DIRECTIONS

1. Over medium-high heat, add the oil to a skillet. Stir in the cabbage, shrimp, chestnuts, mushrooms, garlic, ginger, scallions, salt, and pepper.
2. Thoroughly whisk the egg and water together in a bowl.
3. Lay out the roll wrappers on a work surface, divide the shrimp and vegetable mixture among them, seal the edges with egg wash, and put everything in the basket of your air fryer. Cook at 180°Cahrenheit for 15 minutes, then remove from the basket and serve as an appetizer.

DESSERT RECIPES

Lime Cheesecake

Prep Time: 4 Hrs 10 Min | Cook Time: 4 Min | Serves: 10

Calories: 260.4 | Fat: 23.1g | Carbs: 5.0g | Protein: 7.0g

INGREDIENTS

- 2 tbsp butter, melted
- 2 tsp sugar
- 120g flour
- 60g coconut, shredded

For the filling:

- ½ kg cream cheese
- Zest from 1 lime, grated
- Juice form 1 lime
- 450ml hot water
- 2 sachets lime jelly

DIRECTIONS

1. Mix the coconut, flour, butter, and sugar in a bowl; whisk well. Press this mixture onto the bottom of a pan that will fit your air fryer.
2. In the meantime, add the jelly sachets to a bowl of boiling water and swirl to combine.
3. In a bowl, combine cream cheese, jelly, lime juice, and zest. Whisk vigorously to combine.
4. Add this to the crust, spread it out, and cook it in the air fryer for 4 minutes at 150°C.
5. Store for 4 hours in the refrigerator before serving.

Easy Granola

Prep Time: 10 Min | Cook Time: 35 Min | Serves: 4

Calories: 321.4 | Fat: 7.1g | Carbs: 12.0g | Protein: 7.0g

INGREDIENTS

- 250g coconut, shredded
- 125g almonds
- 125g pecans, chopped
- 2 tbsp sugar
- 125g pumpkin seeds
- 125g sunflower seeds
- 2 tbsp sunflower oil
- 1 tsp nutmeg, ground
- 1 tsp apple pie spice mix

DIRECTIONS

1. Almonds, pecans, pumpkin seeds, sunflower seeds, coconut, nutmeg, and apple pie spice mix should all be combined together in a bowl.
2. Add sugar to a pan that has oil in it and cook over medium heat.
3. Pour this over the mixture of almonds and coconut and well combine.
4. Spread this out on a baking sheet lined with parchment paper that will fit your air fryer. Place in the air fryer and cook at 150°C for 25 minutes.
5. Let your granola cool before cutting and serving.

Strawberry Cobbler

Prep Time: 10 Min | Cook Time: 25 Min | Serves: 6

Calories: 220.4 | Fat: 3.1g | Carbs: 6.0g | Protein: 9.0g

INGREDIENTS

- 180g sugar
- 1 kg strawberries, halved
- 1/8 tsp baking powder
- 1 tbsp lemon juice
- 125g flour
- A pinch of baking soda
- 120ml water
- 3 and ½ tbsp olive oil
- Cooking spray

DIRECTIONS

1. Strawberries should be combined with half the sugar, flour, and lemon juice in a bowl before being poured into an air fryer-compatible baking dish that has been sprayed with cooking spray.
2. In a separate bowl, thoroughly combine the flour with the remaining sugar, baking soda, and baking powder.
3. Include the olive oil and thoroughly combine with your hands.
4. Pour 120ml of water over the strawberries.
5. Add to the fryer and bake for 25 minutes at 180°C.
6. Set the cobbler aside to cool before serving.

Plum Cake

Prep Time: 1 Hr 20 Min | Cook Time: 35 Min | Serves: 8

Calories: 191.4 | Fat: 4.1g | Carbs: 6.0g | Protein: 7.0g

INGREDIENTS

- 200g flour
- 1 package dried yeast
- 30g butter, soft
- 1 egg, whisked
- 5 tbsp sugar
- 80ml warm milk
- 1 kg plums, pitted and cut into quarters
- Zest from 1 lemon, grated
- 30g almond flakes

DIRECTIONS

1. Butter, flour, yeast, and three tbsp of sugar should all be thoroughly combined in a bowl.
2. To create a dough, combine milk and egg and mix for 4 minutes.
3. Place the dough in an air fryer-compatible spring form pan that you've oiled with butter, cover it, and let it aside for an hour.
4. Place the plums on top of the butter, sprinkle with the remaining sugar, and bake for 36 minutes in your air fryer at 175°C. Let cool, then top with almond flakes and lemon zest. Slice and serve.

Lentils and Dates Brownies

Prep Time: 10 Min | Cook Time: 15 Min | Serves: 8

Calories: 161.4 | Fat: 4.1g | Carbs: 3.0g | Protein: 4.0g

INGREDIENTS

- 800g canned lentils, rinsed and drained
- 12 dates
- 1 tbsp honey
- 1 banana, peeled and chopped
- ½ tsp baking soda
- 4 tbsp almond butter
- 2 tbsp cocoa powder

DIRECTIONS

1. Lentils, butter, banana, cocoa, baking soda, and honey should be thoroughly blended in your food processor.
2. Add dates, pulse a couple more times, pour onto a pan that fits your air fryer, spread evenly, and bake for 15 minutes at 180°C.
3. Remove the brownie mix from the oven, slice it, place it on a dish, and serve.

Maple Cupcakes

Prep Time: 10 Min | Cook Time: 20 Min | Serves: 4

Calories: 150.4 | Fat: 1.1g | Carbs: 5.0g | Protein: 4.0g

INGREDIENTS

- 4 tbsp butter
- 4 eggs
- 125ml puree applesauce
- 2 tsp cinnamon powder
- 1 tsp vanilla extract
- ½ apple, cored and chopped
- 4 tsp maple syrup
- 180g white flour
- ½ tsp baking powder

DIRECTIONS

1. Butter in a pan over medium heat, then add applesauce, vanilla, eggs, and maple syrup; whisk; remove from heat; set aside to chill.
2. Combine the flour, apples, cinnamon, baking powder, and stir. Pour the mixture into a cupcake tray and bake for 20 minutes in your air fryer at 175°C.
3. After the cupcakes have cooled, place them on a tray and serve.

Rhubarb Pie

Prep Time: 30 Min | Cook Time: 45 Min | Serves: 6

Calories: 199.4 | Fat: 2.1g | Carbs: 6.0g | Protein: 3.0g

INGREDIENTS

- 300g almond flour
- 8 tbsp butter
- 5 tbsp cold water
- 1 tsp sugar

For the filling:

- 700g rhubarb, chopped
- 3 tbsp flour
- 400g sugar
- 2 eggs
- ½ tsp nutmeg, ground
- 1 tbsp butter
- 2 tbsp low fat milk

DIRECTIONS

1. Mix flour, 1 tsp sugar, 8 tbsp butter, and cold water in a bowl. Stir and knead the ingredients until a dough forms.
2. Move the dough to a floured surface, form a disk, press it flat, cover in plastic, chill for about 30 minutes, then roll and press it into the bottom of an air fryer-compatible pie pan.
3. Whisk together rhubarb, sugar, nutmeg, and 3 tbsp flour in a bowl.
4. Pour the rhubarb mixture into the pie crust, add the eggs and milk to the bowl with the rhubarb mixture, and cook in the air fryer at 195°C for 45 minutes.
5. Slice and serve chilled.

Mandarin Pudding

Prep Time: 20 Min | Cook Time: 40 Min | Serves: 8

Calories: 161.4 | Fat: 3.1g | Carbs: 3.0g | Protein: 6.0g

INGREDIENTS

- 1 mandarin, peeled and sliced
- Juice from 2 mandarins
- 2 tbsp brown sugar
- 120g butter, soft
- 2 eggs, whisked
- 180g sugar
- 180g white flour
- 180g almonds, ground
- Honey for serving

DIRECTIONS

1. Slices of mandarin should be arranged in a loaf pan that has been butter-greased and coated with brown sugar.
2. Place a pan in your air fryer and cook at 180°C for 40 minutes by combining butter, sugar, eggs, almonds, flour, and mandarin juice in a bowl and stirring.
3. Place honey on top of the pudding before serving.

Strawberry Shortcakes

Prep Time: 20 Min | Cook Time: 45 Min | Serves: 6

Calories: 163.4 | Fat: 2.1g | Carbs: 5.0g | Protein: 2.0g

INGREDIENTS

- Cooking spray
- 125g sugar + 4 tbsp
- 180g flour
- 1 tsp baking powder
- ¼ tsp baking soda
- 80g butter
- 250ml buttermilk
- 1 egg, whisked
- 450g strawberries, sliced
- 1 tbsp rum
- 1 tbsp mint, chopped
- 1 tsp lime zest, grated
- 125ml whipping cream

DIRECTIONS

1. Mix the flour, 125G sugar, baking soda, and baking powder in a bowl and stir.
2. In a separate bowl, whisk the buttermilk and egg together before adding to the flour mixture.
3. Place the dough-filled jars in your air fryer and cook for 45 minutes at 180°Cahrenheit. Use 6 jars that have been greased with cooking spray.
4. Strawberries, 3 tbsp sugar, rum, mint, and lime zest should be combined in a bowl and set aside in a cool area.
5. Stir 1 tbsp sugar into the whipped cream in a separate dish.
6. Remove jars, divide strawberry mixture among them, then top with whipped cream and serve.

Sponge Cake

Prep Time: 10 Min | Cook Time: 20 Min | Serves: 12

Calories: 245.4 | Fat: 3.1g | Carbs: 6.0g | Protein: 2.0g

INGREDIENTS

- 700g flour
- 3 tsp baking powder
- 125g cornstarch
- 1 tsp baking soda
- 250ml olive oil
- 350ml milk
- 400g sugar
- 450ml water
- 60ml lemon juice
- 2 tsp vanilla extract

DIRECTIONS

1. Mix the flour, cornstarch, baking soda, baking powder, and sugar together in a bowl.
2. In a separate dish, whisk together the oil, milk, water, vanilla, and lemon juice.
3. Combine the two mixtures, whisk, and then pour the mixture into an air fryer-compatible baking dish that has been oiled. Cook the mixture for 20 minutes at 175°Cahrenheit.
4. After the cake has cooled, slice it and serve.

Printed in Great Britain
by Amazon

15798213R00052

NINJA

DUAL ZONE

AIR FRYER COOKBOOK UK 2023

Prep Time	Cook Time	Serves	Calories
1 hr	15 min	2 person	299.4

INGREDIENTS

- 2 medium salmon fillets • 6 tbsp light soy sauce • 3 tsp mirin • 1 tsp water
- 6 tbsp honey

DIRECTIONS

1. Salmon should be added to a bowl containing a mixture of soy sauce, honey, water, and mirin; whisk well; then add the salmon; rub well; and chill for an hour.

2. Place the salmon in the air fryer, flipping it over after 7 minutes, and cook for 15 minutes at 180°C.

3. In the meantime, heat up the soy marinade in a pan over medium heat, stir it well, cook for 2 minutes, and then turn off the heat.

4. Distribute the salmon among plates, top with marinade and serve.

ISBN 9798366911191